Patterning Techniques

A pattern is a repetition of shapes and lines that can be simple or complex depending on your preference and the space you want to fill. Even complicated patterns start out very simple with either a line or a shape.

Repeating shapes (floating)

Shapes and lines are the basic building blocks of patterns. Here are some example shapes that we can easily turn into patterns:

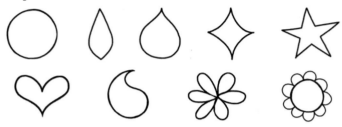

Before we turn these shapes into patterns, let's spruce them up a bit by outlining, double-stroking (going over a line more than once to make it thicker), and adding shapes to the inside and outside.

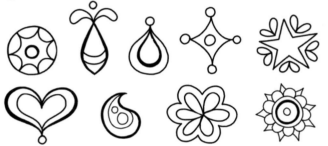

To create a pattern from these embellished shapes, all you have to do is repeat them, as shown below. You can also add small shapes in between the embellished shapes, as shown.

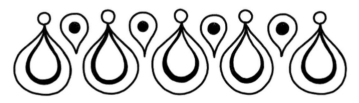

These are called "floating" patterns because they are not attached to a line (like the ones described in the next example). These floating patterns can be used to fill space anywhere and can be made big or small, short or long, to suit your needs.

> ## Tip
> Draw your patterns in pencil first, and then go over them with black or color. Or draw them with black ink and color them afterward. Or draw them in color right from the start. Experiment with all three ways and see which works best for you!

> ## Tip
> If you add shapes and patterns to these coloring pages using pens or markers, make sure the ink is completely dry before you color on top of them; otherwise, the ink may smear.

Repeating shapes (attached to a line)

Start with a line, and then draw simple repeating shapes along the line. Next, embellish each shape by outlining, double-stroking, and adding shapes to the inside and outside. Check out the example below.

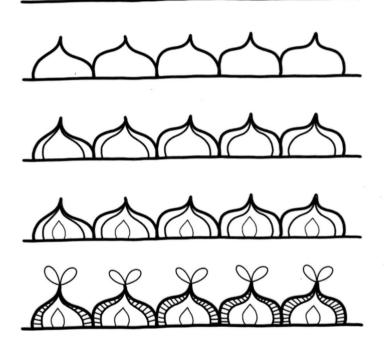

You can also draw shapes in between a pair of lines, like this:

Embellishing a decorative line

You can also create patterns by starting off with a simple decorative line, such as a loopy line or a wavy line, and then adding more details. Here are some examples of decorative lines:

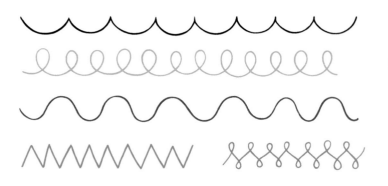

Color repetition

Patterns can also be made by repeating sets of colors. Create dynamic effects by alternating the colors of the shapes in a pattern so that the colors themselves form a pattern.

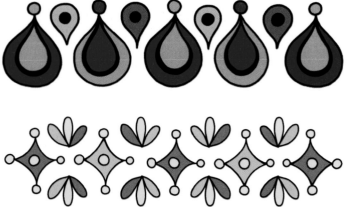

Next, embellish the line by outlining, double-stroking, and adding shapes above and below the line as shown here:

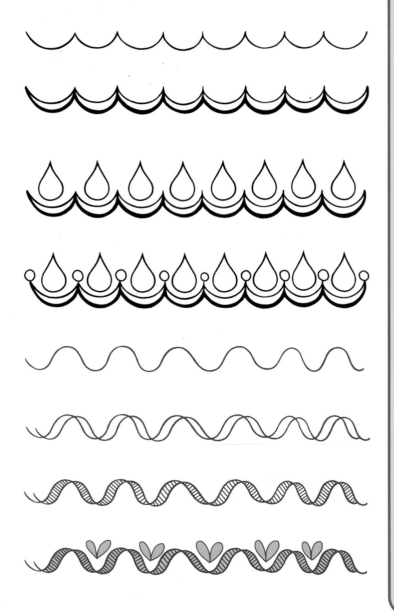

Tip

Patterns don't have to follow a straight line—they can curve, zigzag, loop, or go in any direction you want! You can draw patterns on curved lines, with the shapes following the flow of the line above or below.

These types of patterns look great when attached to the inner or outer edge of a drawing, such as the inside of a flower petal or butterfly wing.

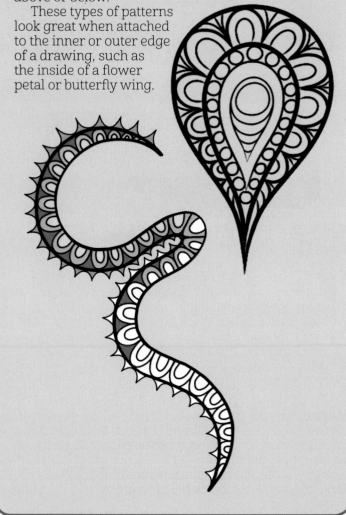

Coloring Techniques & Media

My favorite way to color is to combine a variety of media so I can benefit from the best that each has to offer. When experimenting with new combinations of media, I strongly recommend testing first by layering the colors and media on scrap paper to find out what works and what doesn't. It's a good idea to do all your testing in a sketchbook and label the colors/brands you used for future reference.

Markers & colored pencils
Smooth out areas colored with marker by going over them with colored pencils. Start by coloring lightly, and then apply more pressure if needed.

 + =

marker colored pencil smoother result

Test your colors on scrap paper first to make sure they match. You don't have to match the colors if you don't want to, though. See the cool effects you can achieve by layering a different color on top of the marker below.

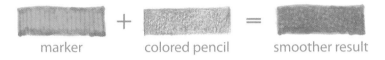

Markers (horizontal) overlapped with colored pencils (vertical).

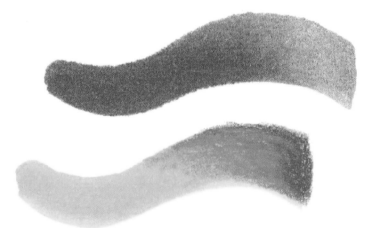

Purple marker overlapped with white and light blue colored pencils. Yellow marker overlapped with orange and red colored pencils.

Markers & gel pens
Markers and gel pens go hand in hand, because markers can fill large spaces quickly, while gel pens have fine points for adding fun details.

White gel pens are especially fun for drawing over dark colors, while glittery gel pens are great for adding sparkly accents.

Shading

Shading is a great way to add depth and sophistication to a drawing. Even layering just one color on top of another color can be enough to indicate shading. And of course, you can combine different media to create shading.

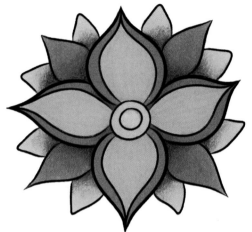

Colored with markers; shading added to the inner corners of each petal with colored pencils to create a sense of overlapping.

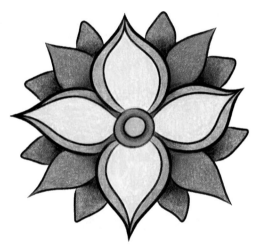

Colored and shaded with colored pencils.

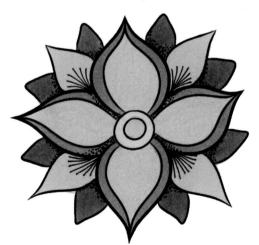

Lines and dots were added with black ink to indicate shading and then colored over with markers.

Color Theory

Check out this nifty color wheel. Each color is labeled with a P (primary), S (secondary), or T (tertiary). The **primary colors** are red, yellow, and blue. They are "primary" because they can't be created by mixing other colors. Mixing primary colors creates the **secondary colors** orange, green, and purple (violet). Mixing a primary color and a secondary color together creates the **tertiary colors** yellow-orange, yellow-green, blue-green, blue-purple, red-purple, and red-orange.

Working toward the center of the six large petals, you'll see three rows of lighter colors, called tints. A **tint** is a color plus white. Moving in from the tints, you'll see three rows of darker colors, called shades. A **shade** is a color plus black.

The colors on the top half of the color wheel are considered **warm** colors (red, yellow, orange), and the colors on the bottom half are called **cool** (green, blue, purple).

Colors opposite one another on the color wheel are called **complementary**, and colors that are next to each other are called **analogous**.

Look at the examples and note how each color combo affects the overall appearance and "feel" of the butterfly. For more inspiration, check out the colored examples on the following pages. Refer to the swatches at the bottom of the page to see the colors selected for each piece.

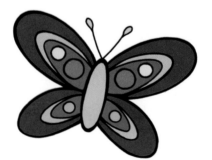

Warm colors

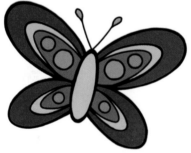

Cool colors

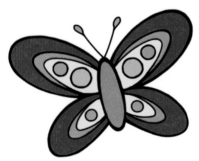

Warm colors with cool accents

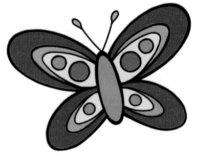

Cool colors with warm accents

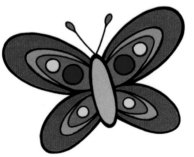

Tints and shades of red

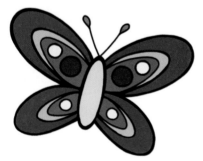

Tints and shades of blue

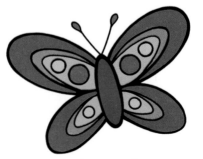

Analogous colors

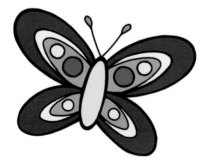

Complementary colors

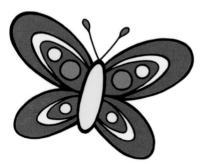

Split complementary colors

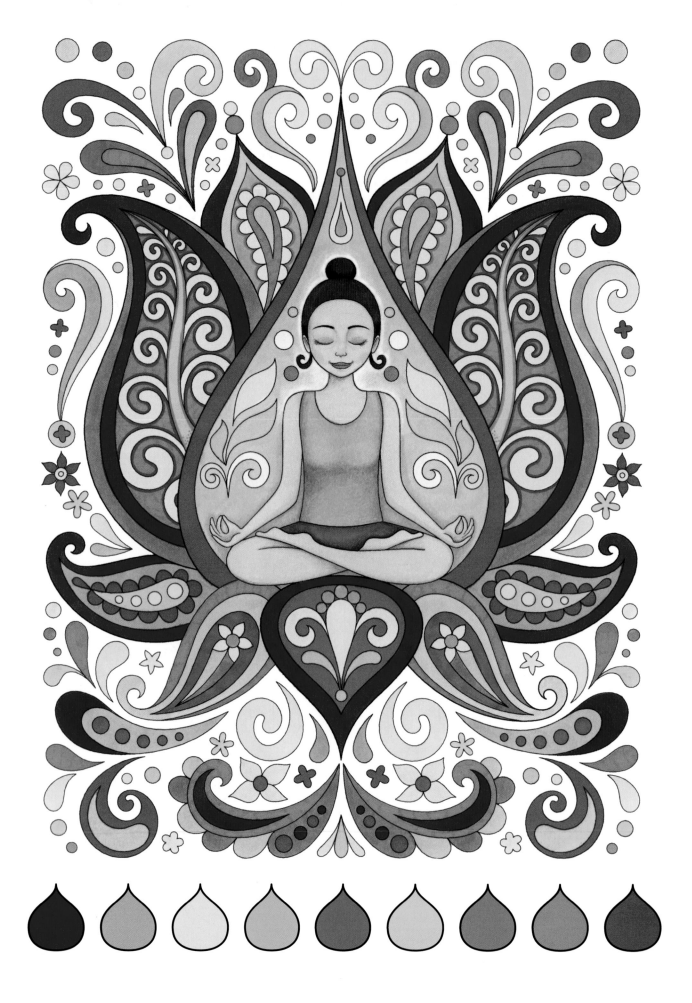

At the center of your being you have
the answer; you know who you are
and you know what you want.

—Lao Tzu

Those who bring sunshine into the lives
of others cannot keep it from themselves.

—J. M. Barrie

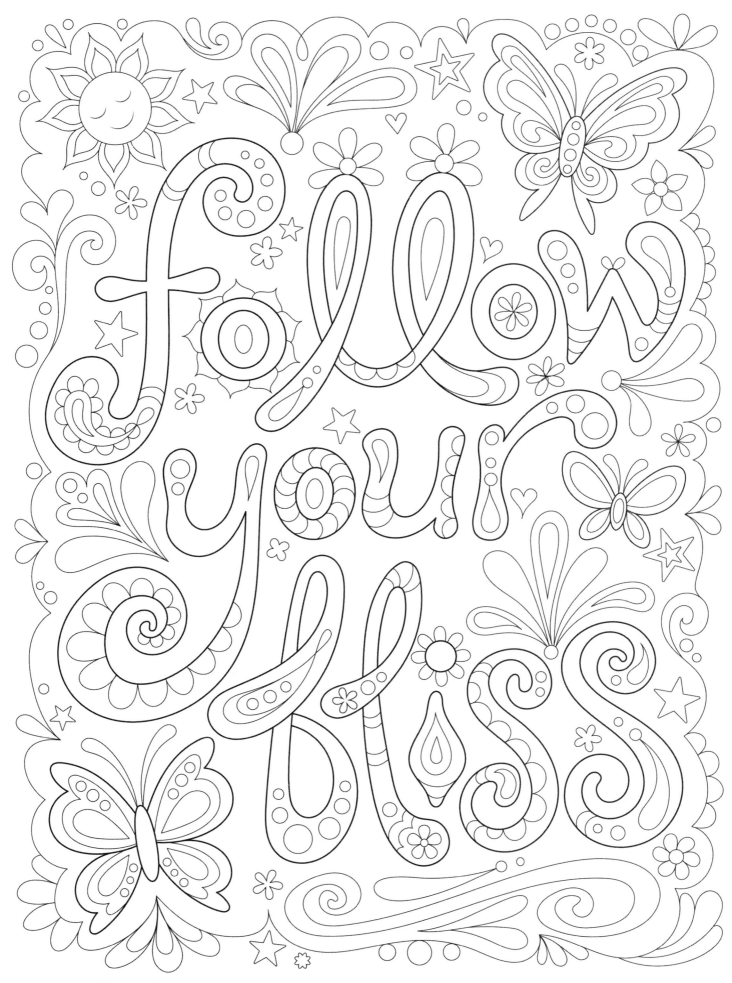

Follow your bliss and the universe
will open doors for you
where there were only walls.

—Joseph Campbell

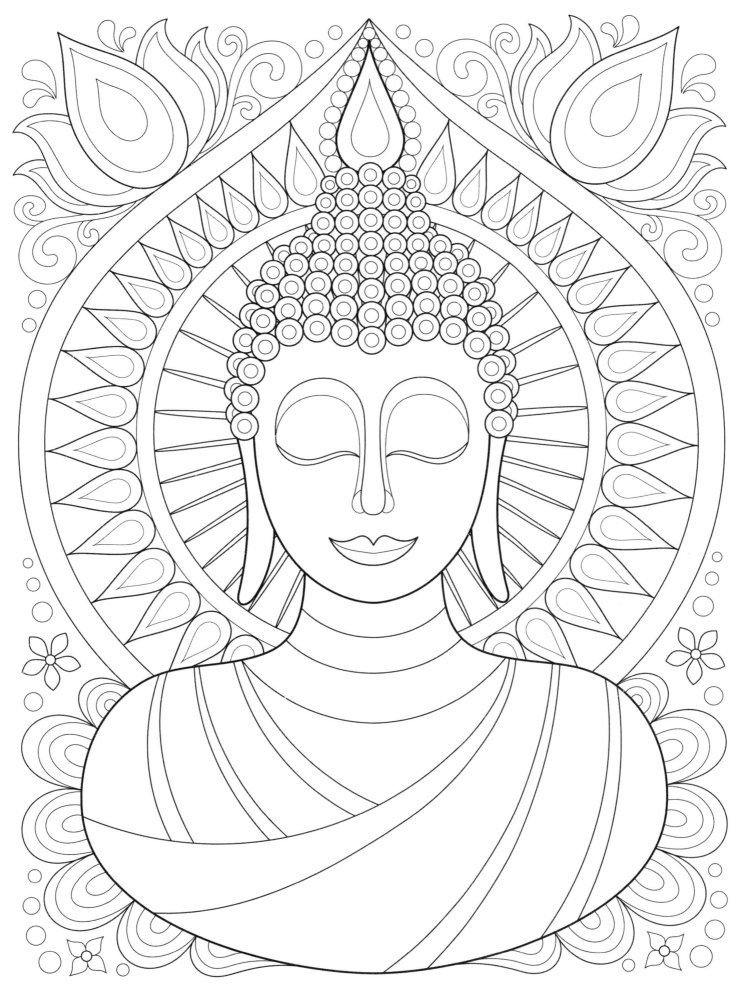

Peace comes from within.
Do not seek it without.

—Unknown

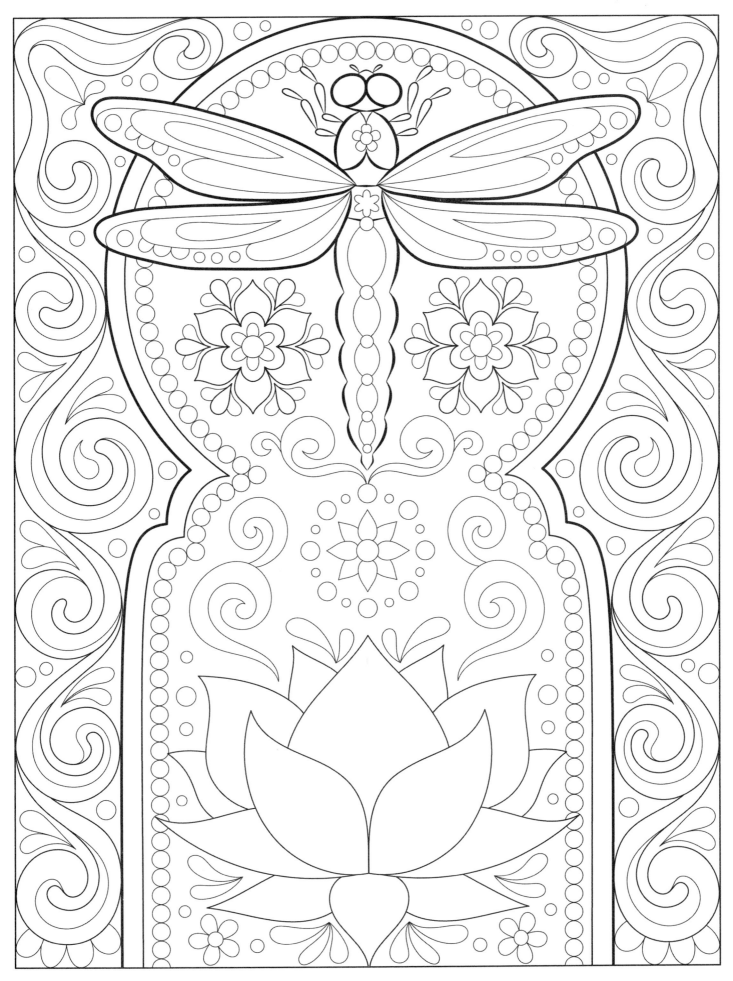

What you think, you become.
What you feel, you attract.
What you imagine, you create.

—Unknown

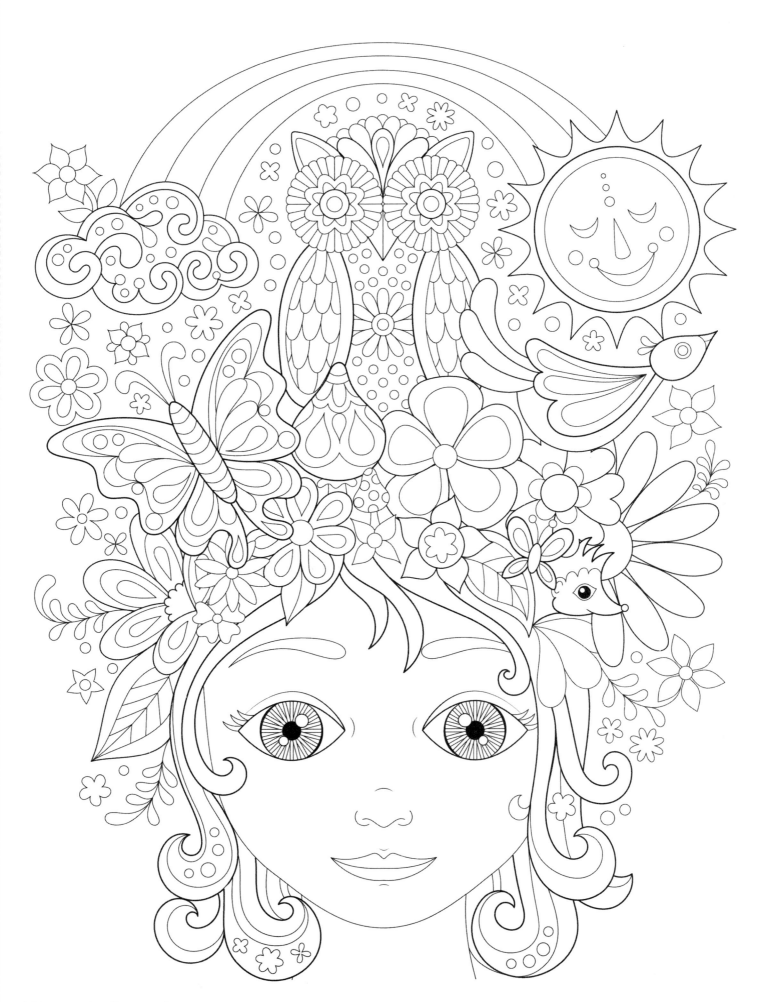

The goal of life is to make your heartbeat match
the beat of the universe, to match your nature with Nature.

—Joseph Campbell

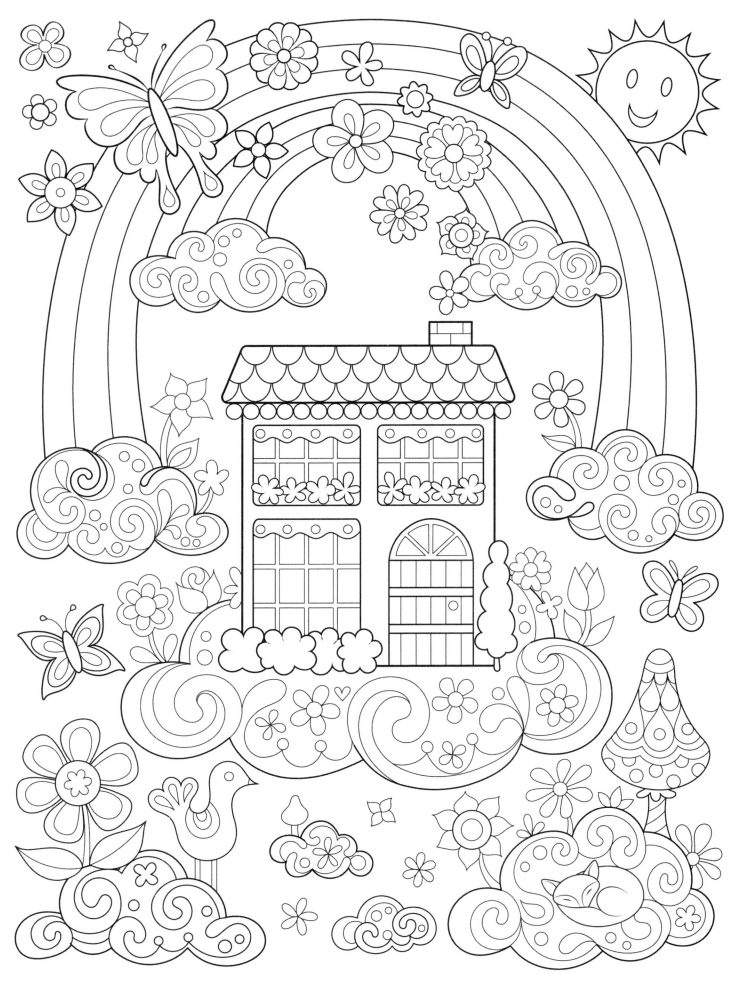

Blessed are they who see beautiful things in humble places where other people see nothing.

—Camille Pissarro

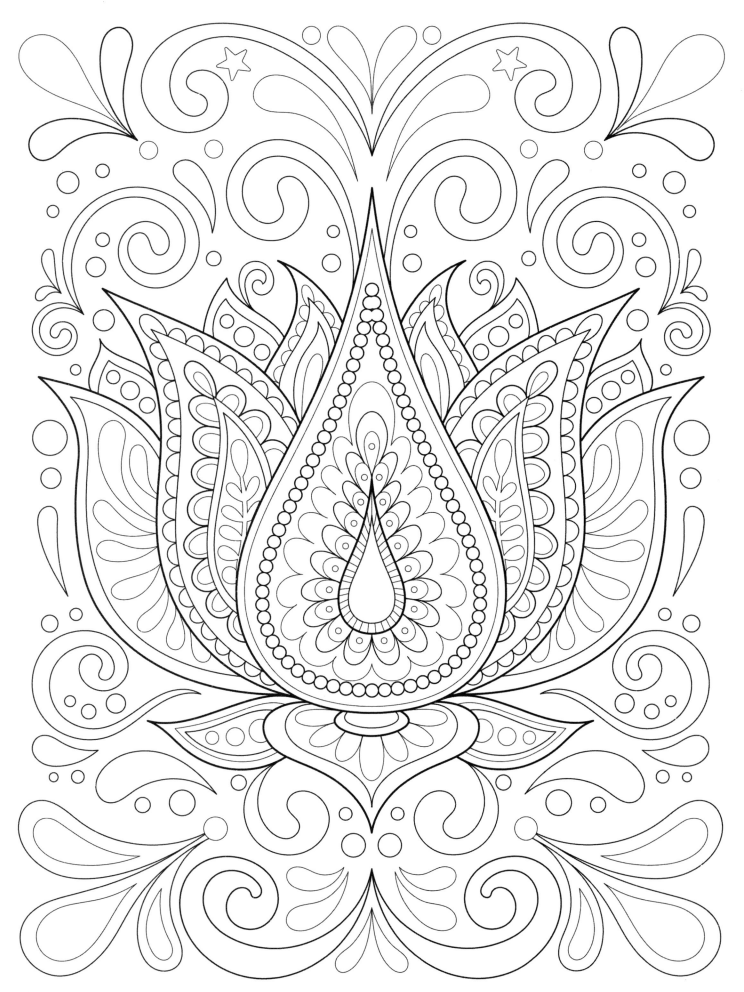

If you feel lost, disappointed, hesitant, or weak,
return to yourself, to who you are, here and now,
and when you get there, you will discover yourself,
like a lotus flower in full bloom,
even in a muddy pond, beautiful and strong.

—Masaru Emoto, *Secret Life of Water*

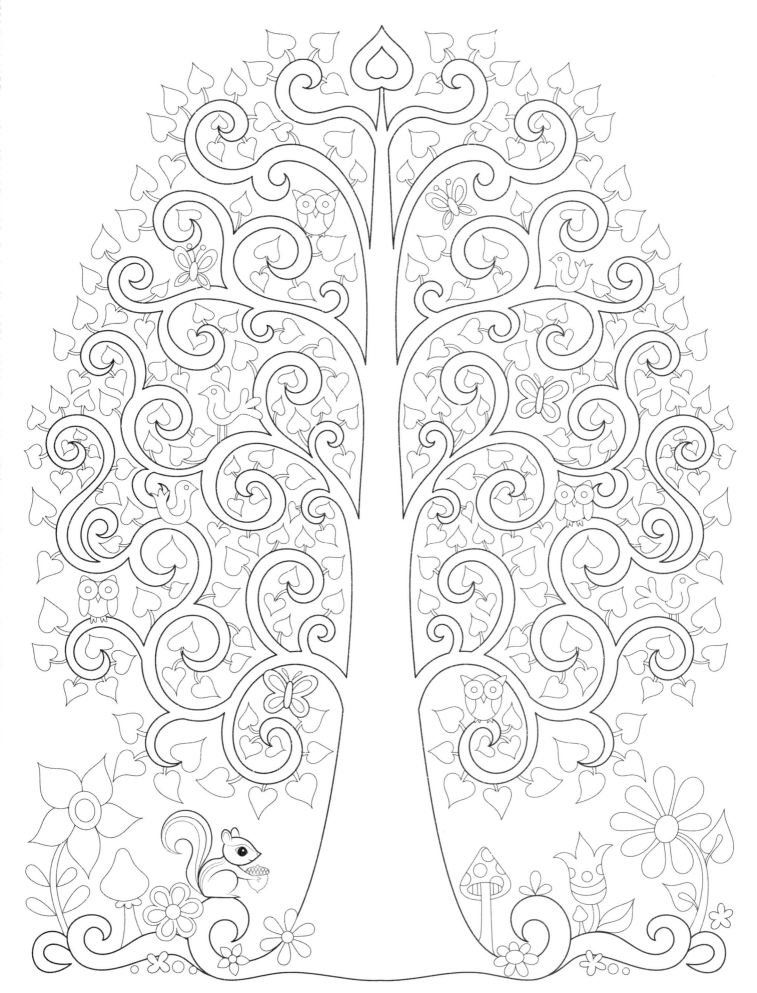

Don't go through life, grow through life.

—Eric Butterworth

Refuse to be average.
Let your heart soar as high as it will.

—A. W. Tozer

Remember that your natural state is joy.

—Wayne Dyer

tune in to yourself

The map to our guidance lies within.
Always follow your heart!
When your heart feels at peace,
rest assured, you are on the right track.

—Angie Karan Krezos

Nothing is more important than
reconnecting with your bliss. Nothing is
as rich. Nothing is more real.

—Deepak Chopra

The philosophy of life is this:
Life is not a struggle, not a tension...life is bliss.
It is eternal wisdom, eternal existence.

Maharishi Mahesh Yogi

Embrace this moment. Let go of what once was.
And know that more beauty is ahead.

—Katrina Mayer

In the midst of our lives, we must find
the magic that makes our souls soar.

—Unknown

May your joys be as deep as the ocean,
your sorrows as light as its foam.

—Unknown

Sometimes you just have to take the leap
and build your wings on the way down.

—Kobi Yamada

Let yourself be silently drawn by the strange pull
of what you really love. It will not lead you astray.

—Rumi

When you love and laugh abundantly
you live a beautiful life.

—Unknown

Be bold enough to use your voice,
brave enough to listen to your heart,
and strong enough to live the life
you've always imagined.

—Unknown

What you seek is seeking you. ~Rumi

The things you are passionate about
are not random, they are your calling.

—Fabienne Fredrickson

When you realize how perfect everything is,
you will tilt your head back and laugh at the sky.

—Unknown

Let love light your way

Love the life you live.
Live the life you love.

—Bob Marley

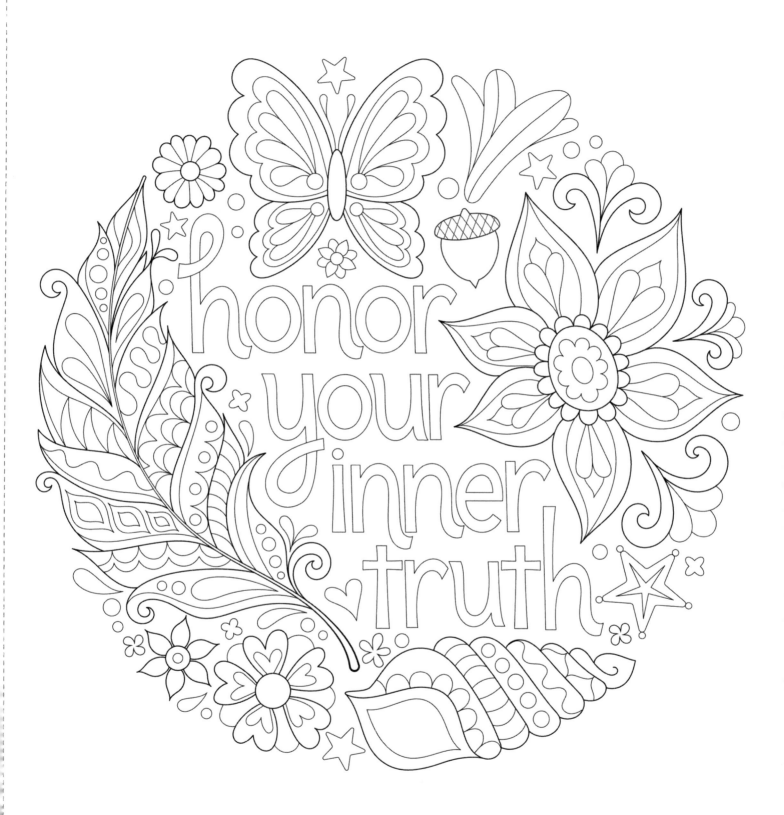

You can't live a lie.
You have to follow your heart.

—Paul Weller

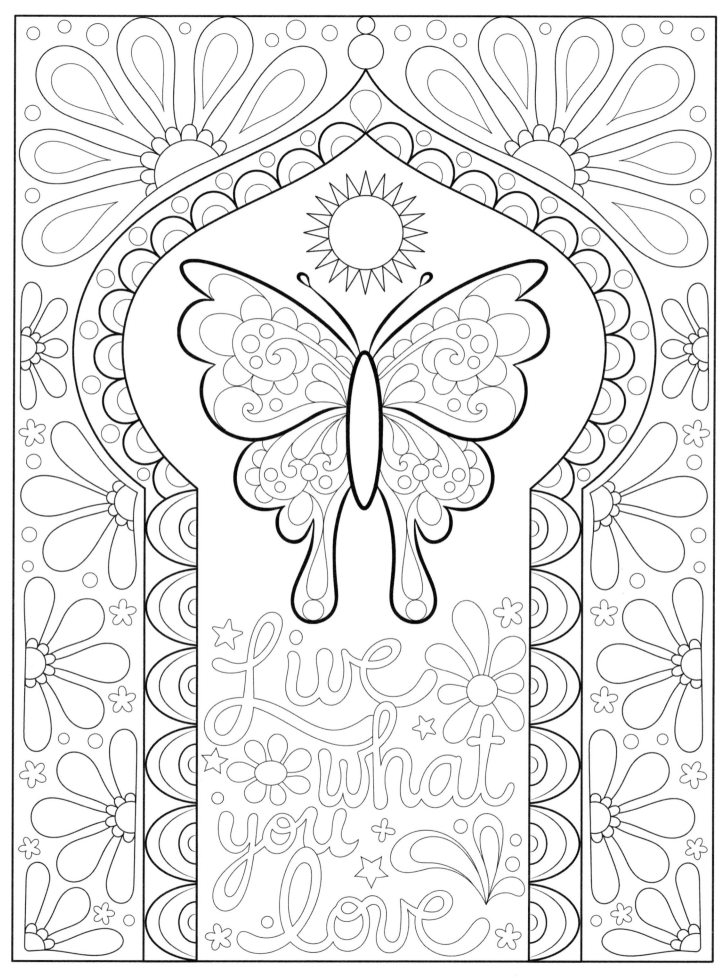

Live what you love

If you can't figure out your purpose,
figure out your passion. For your passion will lead
you right into your purpose.

—T. D. Jakes

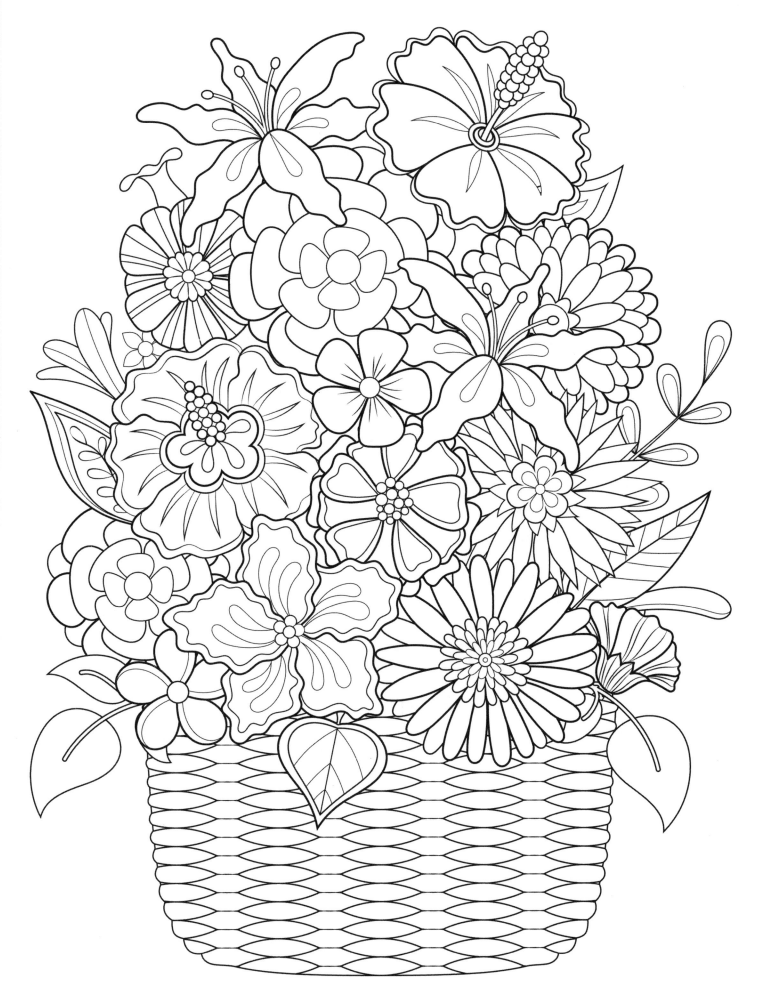

Invent your world.
Surround yourself with people, color,
sounds, and work that nourish you.

—Sark

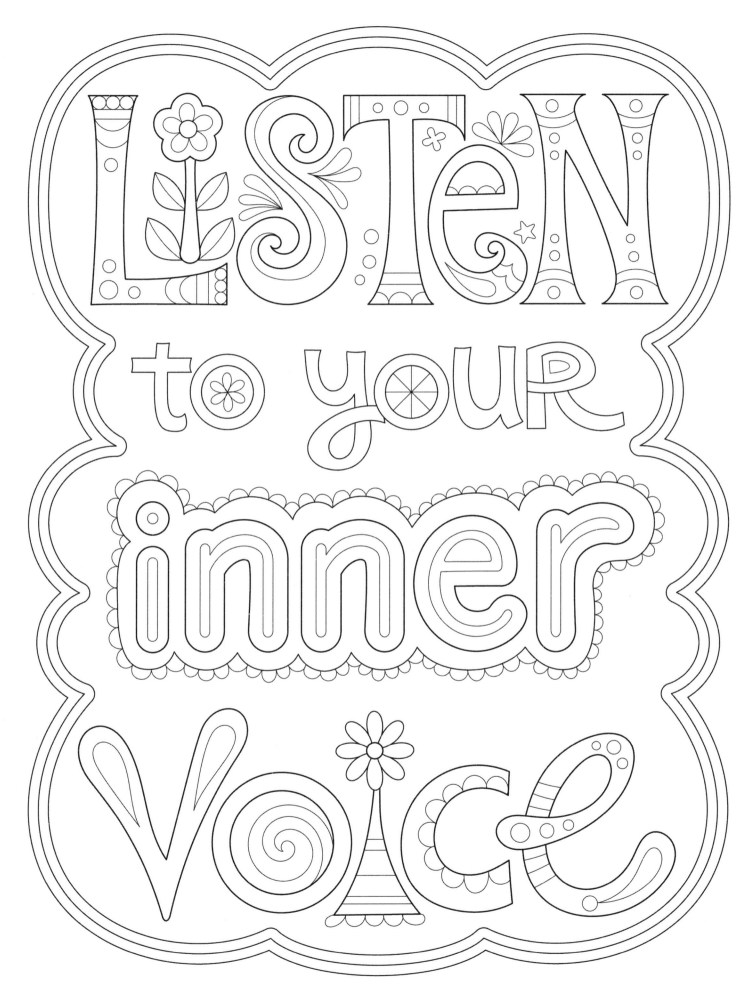

Don't let the noise of others' opinions
drown out your own inner voice.

—Steve Jobs

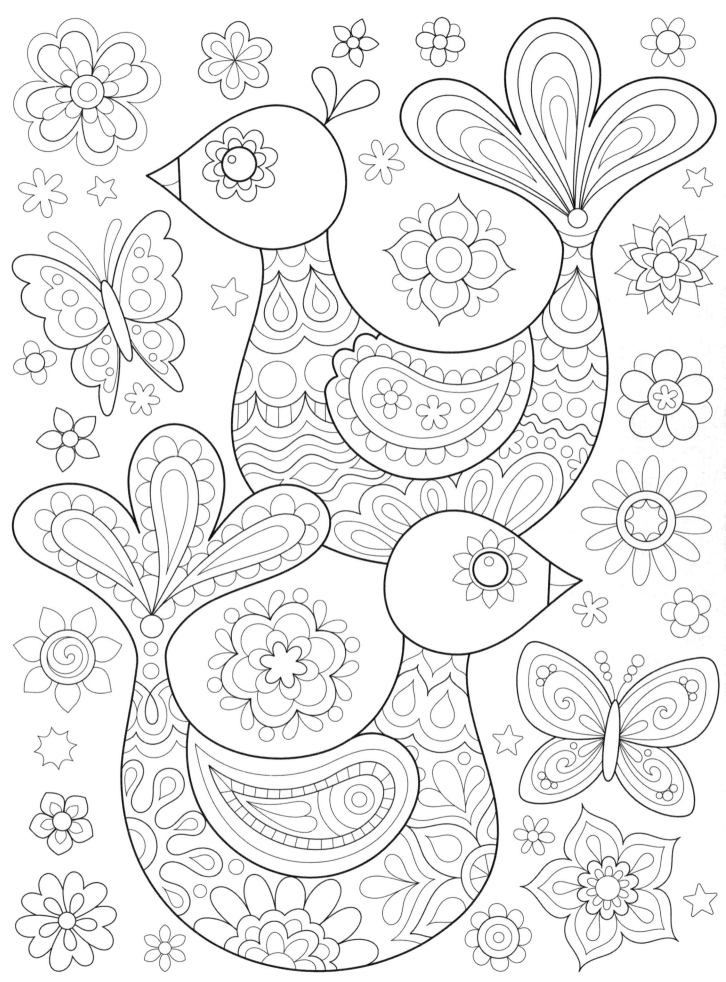

Don't waste a minute not being happy.
If one window closes, run to the next window—
or break down a door.

—Brooke Shields

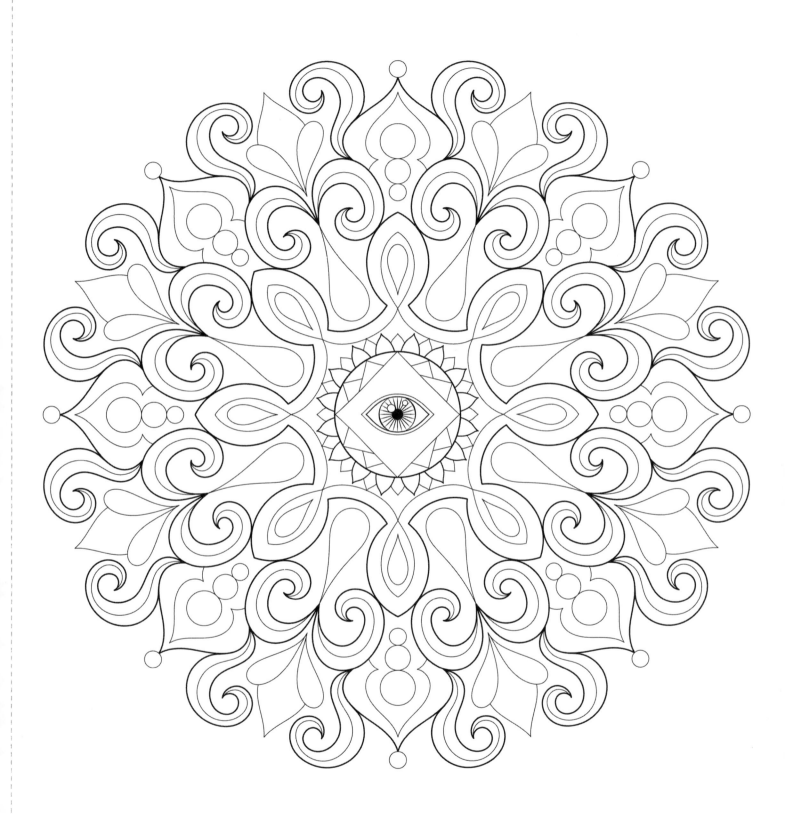

Nothing can dim the light
that shines from within.

—Maya Angelou